BUILDWAS AF

SHROPSHIRE

David M. Robinson PhD FSA

In the summer of 1135, Roger de Clinton, Bishop of Chester, brought a small colony of monks to England from the Norman abbey of Savigny. He settled the brothers at Buildwas, on the banks of the River Severn in Shropshire. Just 12 years later, Buildwas Abbey was to find itself part of the largest, most powerful and most widespread of all the monastic families in medieval Europe – the Cistercians.

Under the gifted Abbot Ranulf (1155–87), monastic life at Buildwas began to flourish. The abbey steadily improved its economic viability, building up a sizeable landed estate. Meanwhile, work had begun on the construction of a characteristic twelfth-century Cistercian abbey church, and on three principal ranges of monastic buildings grouped around a northern cloister.

Despite a number of setbacks in the later fourteenth and fifteenth centuries, the community maintained its daily round of service to God. In 1536, however, monastic life was brought to an abrupt end, during the first round in the suppression of the monasteries. The abbey and most of its property were granted to Sir Edward Grey, Lord Powis. Parts of the former monastic buildings were soon converted for use as a grand Tudor mansion. In time, the property was reduced in size and became a tenanted farm. The principal ruins, those of the church and main claustral ranges, have been cared for by the state since 1925, and are the subject of this guidebook.

❖ CONTENTS ❖

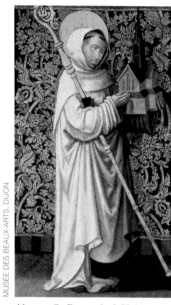

Above: *St Bernard of Clairvaux,
driving force behind the expansion
of the Cistercian order*

Title page: *A thirteenth-century
manuscript illustration of a
Cistercian monk*

Published by English Heritage,
23 Savile Row, London W1S 2ET
www.english-heritage.org.uk

Copyright © English Heritage 2002
First published by English Heritage 2002
Photographs by English Heritage Photographic
Unit and copyright of English Heritage,
unless otherwise stated

Edited by Elizabeth Rowe
Designed by Joanna Griffiths
Production by Richard Jones
Printed in England by Empress

C40, 01/03, 00054, ISBN 1 85074 815 2

MUSÉE DES BEAUX-ARTS, DIJON

A TOUR OF THE ABBEY

SITE AND PRECINCT

The impressive ruins of the Cistercian abbey of Buildwas are to be found in a wooded and picturesque setting on a terrace above the south bank of the meandering River Severn.

In the tour offered here, we shall look at the most important elements of the medieval abbey, namely the church and the principal cloister buildings. It must be remembered, however, that these represent but a small part of the entire Cistercian complex. The abbey precinct as a

An aerial view of Buildwas Abbey in its setting on the south bank of the River Severn, with the Wrekin the climax to the superb vista

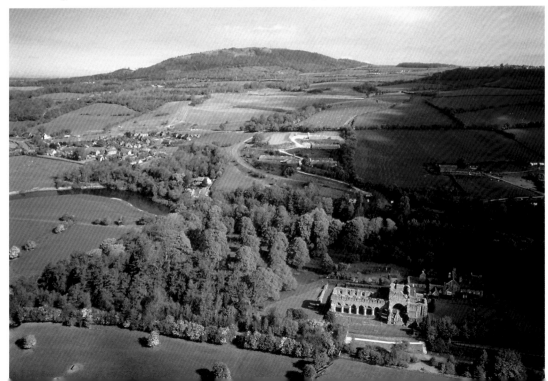

ENGLISH HERITAGE/SKYSCAN BALLOON PHOTOGRAPHY

whole may have covered up to 34 acres (13.7ha), enclosed on the north by the River Severn, and on the west by a smart-flowing tributary stream.

Within the bounds of the full precinct, we have to envisage numerous other structures, including mills, barns, stables and workshops, together with paddocks, meadows and fishponds. Following the suppression of the abbey, and the construction of a grand Tudor dwelling house on the site, this monastic landscape would have been transformed, with tasteful gardens and a parkland for the chase becoming the order of the day.

The abbey church seen from the ticket office. In the foreground is the south transept, with the tower beyond, and the nave to the left

Once past the ticket office, the formal tour begins with the abbey church, by far the most prominent survival at the site. From here, we shall move to the cloister court on the north side, progressing around each of the three main cloister ranges in turn. Key points in the tour are picked up in a numbered sequence, linked to the ground plan on the inside back cover.

THE CHURCH

Begin your tour near one of the benches beyond the ticket office, noting how the abbey church is laid out.

Here, we are standing on the south side of the building, the whole of which is orientated on an east-to-west axis. To your left (west) is the nave [1], distinguished by the sturdy piers, or columns, which run along its full length. To the right (east) there is a low tower, positioned over the 'crossing' at the centre of the church [2], and right again lies the presbytery [3]. In the foreground are the low foundations of a large chapel [4], a later addition to the building.

Sadly, there is no documentary record to tell us anything about the progress of construction work on the church, though the stylistic evidence suggests it was begun about 1150 and may have been completed by about 1190.

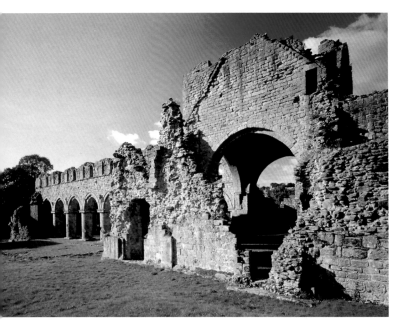

The design is typical of that favoured by the Cistercians from the mid-twelfth century onwards. It is of cruciform, or cross-shaped, plan with a relatively small square-ended presbytery [3], transepts to either side of the crossing [5 and 6], each with two diminutive eastern chapels, and an aisled nave of seven bays (a bay being defined as the space between each pair of circular piers).

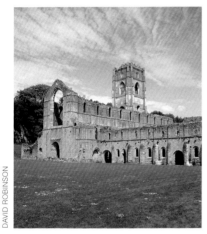

The construction of the church was contemporary, for example, with the new church begun in the 1150s at Fountains Abbey in North Yorkshire. The significance of Buildwas lies in the fact that, unlike so many other abbey churches of this era, it remained largely unaltered throughout the later Middle Ages.

The walls of the finished church were coated, inside and out, with a thick rendering of plaster. This was in turn covered with an off-white limewash, marked out with lines to suggest joints of fine-quality masonry. The lines were probably deep red, a colour favoured not only by the Cistercians, but generally in this region.

One last point to grasp before entering the building is that Buildwas, like all early Cistercian churches, was intended to serve two entirely different communities. The nave was the preserve of the abbey's lay brothers, or *conversi*. They were literally converts, coming to the monastic life as adults and providing the backbone of the early agricultural workforce. The choir monks, who followed a much stricter daily regime, and whose lives were regulated by long hours spent at prayer, occupied the eastern end of the building.

DAVID ROBINSON

Above: *The plan of the Burgundian abbey of Fontenay (Côte-d'Or) is seen as the archetypal form preferred by the Cistercians from the mid-twelfth century*

Left: *The construction of the church at Buildwas was contemporary with the new work begun at Fountains Abbey, North Yorkshire in the 1150s*

DAVID ROBINSON

A Cistercian monk, perhaps a lay brother, at work reaping corn in a manuscript illustration of 1111. The lay brothers provided the backbone of the order's early agricultural workforce

BIBLIOTHÈQUE MUNICIPALE, DIJON, MS. 170, f. 75v

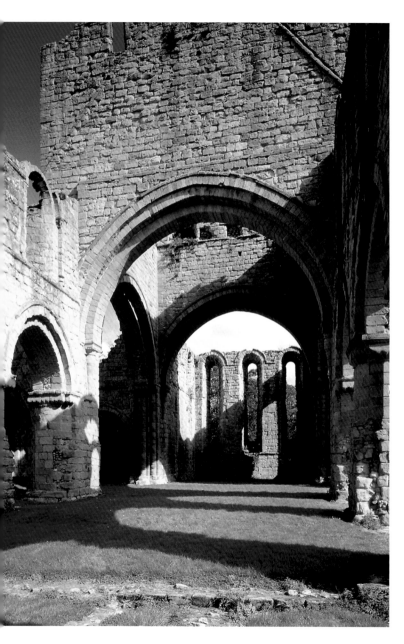

The choir and presbytery, looking east from the nave

Make your way into the church and stand in the 'crossing' [2], the space beneath the central tower.

Choir and Presbytery

Effectively, you are now standing in the monks' choir, originally a discreet and very private space enclosed on three sides. To the west, it terminated at a partition screen known as the *pulpitum*, probably running between the first pair of nave piers [7]. To the north and south, the choir was separated from the aisles by solid stone screen walls linking the gaps between the piers. These walls, of which the stubs remain, also extended for a considerable distance under the north and south arches of the crossing. The choir stalls themselves were probably of solid oak, and backed on to these various screens on all three sides.

The choir was at the heart of what St Benedict had called the *opus Dei* (the work of God) – the framework for the monastic day. From the *Rule* of the saint, the Cistercians followed the Old Testament prophet, gathering in the choir to sing God's praises seven times a day, and at night rising to confess him. This meant a long round of eight divine offices here in

the choir, beginning with *Nocturns* well before dawn and ending with *Compline* around dusk.

Now enter the presbytery [**3**].

Mass was celebrated at the high altar, located under the three windows at the east end of the presbytery. Initially, these windows (probably filled with an opaque glass known as grisaille) were arranged in two tiers. Around 1200, or soon after, the divisions were removed to create tall single openings. Notice the surviving traces of the lower tier of rounded heads to the edge of the jambs. To the left, there is a small window in the north wall of the presbytery; a similar example in the south wall has been extended in length, presumably when the east windows were modified.

In lowering the south window, the builders broke through a round-headed recess set into the wall face. This recess may have been a piscina, in which the water used to cleanse the sacramental vessels for the Mass was drained away. To the right, there is a similar recess that presumably served as the credence, the place where the sacred elements (bread and wine) were stored before the offertory. Further right, you will see a sedilia [**8**], three stone seats used by the monks celebrating mass. It is clearly an insertion, the arched-heads of the seats adorned with early thirteenth-century 'dog-tooth' ornament.

Over on the north side of the presbytery the wall face is extremely plain. Near the middle, however, just below a decorative horizontal 'string-course', you will see a narrow opening with rather rough edges. An insertion into the original fabric, this was a 'squint', allowing one of the abbey's later medieval inmates to look down on the high altar from a small chamber over the north transept.

Adding to its importance, the presbytery was covered with a stone vault. The corbels from which the ribs of the vault were carried outwards can be seen high up on the side walls, and also in the corners abutting the tower.

Move back to the crossing to observe the details of the tower.

Above: *The sedilia and other features in the south wall of the presbytery*

Left: *A late-medieval manuscript illustration of 'white monks' in their choir stalls*

A drawing by Joseph Potter (1847), showing one of the corbels supporting the rib vaults over the presbytery

Below: *Set over the central crossing, the tower is supported on four great pointed arches*

Below right: *An engraving published in 1814 showing the tower, with the gabled roof crease of the nave clearly visible*

Tower

The tower does not appear to have been part of the original design of the church. In fact, the early Cistercians sought to curb the building of towers, especially those of excessive height containing bells. In 1157, however, it seems the General Chapter (p. 29) relaxed its general prohibition, after which comparatively low 'lantern' towers were introduced at a number of English abbeys, including here at Buildwas.

There is no doubt that on the north and south sides of the crossing the tower arches were primary, and were carried on shafted half piers with a mix of scallop and foliage capitals. In contrast, you will see that the east and west arches were insertions, cut untidily into the wall faces and supported on large cone-like corbels.

If you stand back and look up at any of the four exterior sides of the tower, the steep pitch of the gabled roof of that particular arm of the church is clearly visible. Above the roofs, there were eight small round-headed windows (two to each side), giving extra light to the choir below.

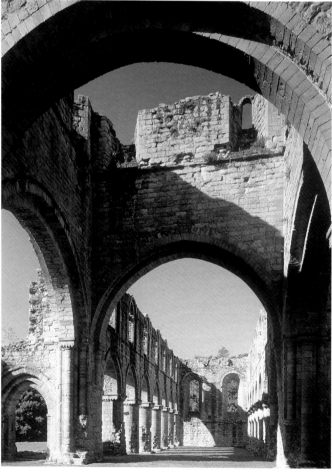

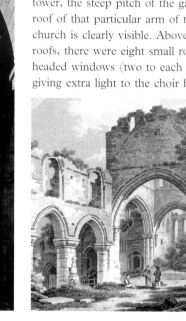

Now step into the north transept [5].

North Transept

The north transept was arranged in two bays, with the floor level in the outermost bay being slightly higher so as to accommodate the 'crypt' below (p. 15). In the north wall, near the left-hand corner [9], there is the base of a raised doorway through which the monks entered the church from their dormitory during the hours of darkness (p. 20). They came down by way of the night stair, the upper steps of which survive in the thickness of the wall. To the right, at floor level, there is another doorway that gives access to the sacristy or vestry (p. 15).

In the east wall, you will see two plain archways leading to small chapels, used by individual choir monks to offer a daily private Mass [10 and 11]. The arrangements were very similar in both, with a single east window and an altar below. In the south wall of each chapel, there is a round-headed recess, which presumably served as the credence. Next to this was a projecting stone piscina, for the most part broken away. The chapels featured stone rib vaults (the ribs now lost), and extensive traces of the plaster that covered the walls still remain.

Walk back through the crossing to the south transept [6].

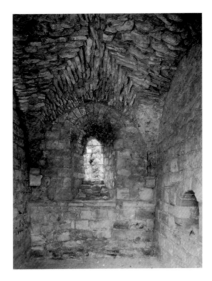

South Transept

In the far (south) wall of the south transept you will find two doorways. That to the left opened into a small square turret housing a spiral stair that climbed up to the roof spaces. The doorway to the right was used for processional purposes, and probably gave access to the monks' cemetery to the east of the church. Above these doors, the upper part of the wall was doubtless pierced by several windows.

The eastern chapels [12 and 13] were of the same form as those in the north transept, though the arch into the southernmost example is much ruined.

Return to the crossing and turn left into the nave [1].

Left: *All four transept chapels were of similar design. Each was covered with a rib vault, with an altar beneath the east window*

Below: *The round-headed recess set into the south wall of all the transept chapels probably served as a credence shelf. The larger recess in this view of the southernmost chapel was perhaps an aumbry or cupboard*

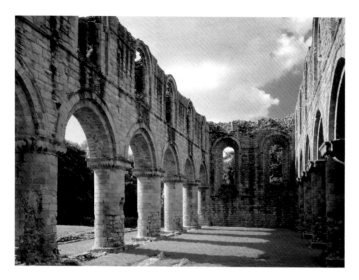

A general view of the nave, looking west along the south arcade

The wall foundations across the middle of the nave mark the position of a screen separating the monks' choir (to the east) from the lay brothers' choir (to the west)

Nave

The nave [1] is of the restrained architectural form preferred by the Cistercians, but it also owes a great deal to early Romanesque church-building in the west of England. It is of seven bays, with the slightly pointed arches of the arcades set on sturdy columnar piers. Over the arcades, a section of blank walling is finished with a horizontal string-course, inside and out. Above this, the upper level of the elevation (the clerestory) is filled with round-headed windows, one to each bay. The whole of the nave was covered with timber ceilings.

The main central vessel of the nave was entirely cut off from the north and south aisles [14 and 15] by solid screen walls. From the surviving stubs, you will see that these walls were some 6 feet (1.8m) high, and that they continued westwards from the monks' choir to run along the entire inner face of the nave arcades.

The central area of the nave was also subdivided along its length by at least two transverse partition screens. In the thirteenth-century church, the first screen – the *pulpitum* [7], noted above – would have run at the back of the monks' choir stalls, probably between the first pair of nave piers. The bay to the immediate west would then have served as the retrochoir, the place where aged and infirm monks were allowed to sit during the offices.

A second screen (the rood screen) ran between the next pair of nave piers [16], its position marked today by a low wall of indeterminate date. There are socket holes in the walls above the piers at this point. These may well have supported timber beams, on which the rood (an image of the crucified Christ), would have been carried. Notice that the floor level also drops at this point, indicating at least one step. To the west again are fragments of walling, in the position where we might expect the nave altar or altars. Beyond this point was the lay brothers' choir.

The lay brothers were illiterate men (and required by their specific

rule book to remain so), but they took religious vows and wore the habit, attending mainly night offices in this part of the abbey church. Their stalls would have faced the centre of the nave, backing on to the lateral screen walls. In the later Middle Ages, following the demise of the lay brotherhood, the naves of Cistercian churches were used mainly for processional purposes.

The north and south aisles [**14** and **15**] served chiefly to link the two ends of the church. Their outer walls, for the most part reduced to ground level, presumably featured

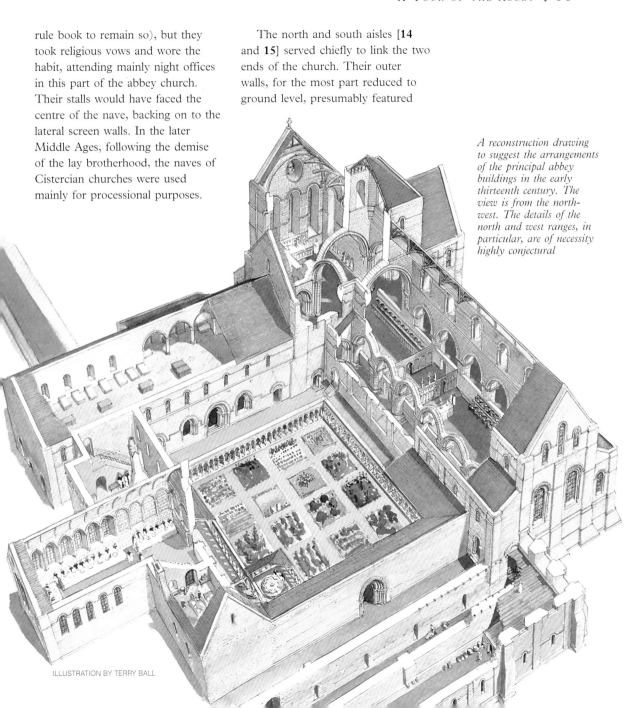

A reconstruction drawing to suggest the arrangements of the principal abbey buildings in the early thirteenth century. The view is from the north-west. The details of the north and west ranges, in particular, are of necessity highly conjectural

ILLUSTRATION BY TERRY BALL

Fragments of tile pavements of around 1300, together with several grave slabs, survive in the floor of the south chapel

round-headed windows; those on the north side must have been set at a higher level to clear the cloister roof outside. You will see that the east ends of the aisles were marginally higher, with steps located between the second and third piers.

There were two doorways in the outer wall of the north aisle. That in the western corner [17] was first used by the lay brothers, connecting with their 'lane' on the west side of the cloister (p. 22). To the east was the processional doorway [18], opening into the east walkway of the cloister. This was used by the choir monks to enter the church during daylight hours.

Leave the nave near the steps in the south aisle and enter the rectangular area marked by low foundations [4].

South Chapel

Set against the south aisle of the nave, these foundations mark the position of a large rectangular chapel, added to the church before the end of the thirteenth century.

The walls of the chapel were supported by substantial corner buttresses, and by a row of buttresses along the south side, suggesting the chapel may have been covered with a stone vault. There was a separate entrance porch on the west side [19], but the chapel is also likely to have opened directly into the south wall of the nave.

There are a number of thirteenth-century grave slabs set into the ground. Also, in the chapel and in the porch, there are fragments of decorative tile pavements dating from around 1300. These tiles remind us that during the later Middle Ages much of the floor surface in the church as a whole would have been similarly paved.

Leave the chapel and walk down the slope, turning right to look at the west front of the church [20].

West Front

The height and mass of the west front make it perhaps the most striking survival of the entire building. The main features are the

One of the windows in the west front of the church, drawn by Joseph Potter (1847)

two large round-headed windows, both of which had jamb shafts and a carved decorative head. There were three more windows in the gable above (now lost), and another in the south aisle.

Interestingly, there is no doorway in the west front of the church. It has been suggested that the fall in the ground level would have made it difficult to include one, but this is not entirely convincing.

Return up the slope, and walk back along the nave, leaving near the position of the east processional doorway on the left-hand side [18]. Modern wooden steps lead down into the cloister.

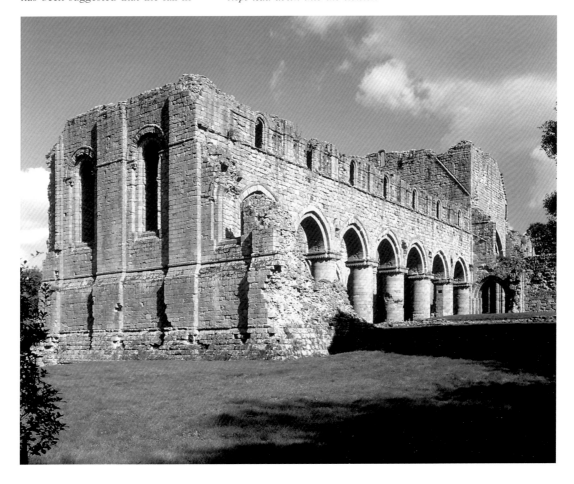

The west front of the abbey church, seen from the south-west

The Cloister and Monastic Buildings

When not attending the divine offices within the abbey church, the choir monks spent much of their time in the great cloister [21]. This square open court, or garth, was surrounded on each side by broad walkways, or alleys. At most abbeys, the cloister was located on the south side of the nave, but here it lay to the north, allowing for the sloping topography and taking advantage of drainage towards the River Severn.

As laid out, the cloister walkways would have been covered with lean-to roofs. To the edge of the garth,

The monastic buildings were grouped around three sides of the cloister. The low foundations in this view mark the position of the open arcades around the garth. It is the east range of buildings, seen in the distance, which is the best preserved

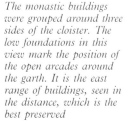

these roofs were carried on open arcades of round-headed arches supported on rows of slender columns. Today, the line of the arcades survives as low stone footings [22]. The walkways themselves provided living space for the community, a place to take exercise and to read and meditate during periods of *lectio divina* (p. 16).

The present grass cover over the central garth is misleading. We should probably imagine this laid out as a garden, with flowers, herbs and even fruit trees. At the corners, there are traces of stone foundations, indicating diagonal buttresses put up to support the arcades at some point in the later Middle Ages. By this time, the walkways would have been paved with decorative glazed tiles.

Begin your tour of the claustral buildings with the east range, which runs from the bottom of the wooden staircase along the right-hand side of the garth.

The East Range

The east range of monastic buildings was reserved almost exclusively for the use of the choir monks. Arranged over two storeys, and probably completed in the third quarter of the twelfth century, its layout was similar to that seen in Cistercian abbeys across Europe.

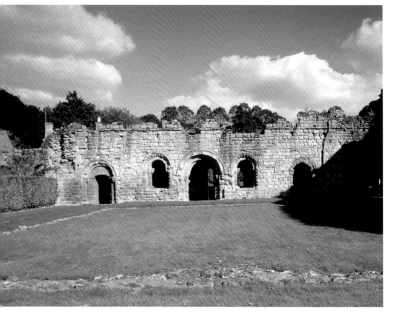

Start at the doorway closed by an iron gateway [23], from which steps lead down to a chamber below ground level (not accessible to the public).

Crypt

Often described as a 'crypt', this narrow stone-vaulted chamber is a most unusual feature in a Cistercian context. The two west bays are quite plain, but the east bay seems to have been used as a chapel. It had a small splayed window above the altar in the east wall (later converted to a doorway), and another in the north wall. As in the transept chapels, there is a credence recess in the southern wall, again with a projecting piscina alongside.

At a practical level, the 'crypt' served to carry the outer bay of the north transept and its chapel over a dip in the ground level.

Continue to the first doorway in the east range itself.

Sacristy and Book Room

This doorway leads into a two-bay vaulted chamber set at the same level as the adjacent cloister alley [24]. There are two cupboards set into round-headed recesses in the north wall, one to each bay.

In the customary Cistercian layout, we might expect there to have been a partition separating the two bays. If this was the case, the

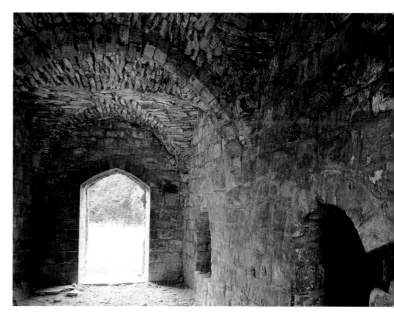

west bay served as the book room, or *armarium*, where some at least of the abbey's fine collection of volumes could be stored for use in the cloister. The bay to the rear, entered via a short flight of steps down from the north transept, must have been the sacristy, or vestry (*vestiarium*), the place where the vestments, altar cloths and liturgical vessels used in Masses and other services were kept in safety.

The plain round-headed doorway in the east wall was a later insertion. The enclosed space beyond must have been roofed over at some point [25]. An area of its tiled floor remains. It may have afforded additional space for the sacristy.

The interior of the sacristy and book room, looking west

In this thirteenth-century manuscript illustration, St Bernard writes while two monks read at his feet

BODLEIAN LIBRARY, OXFORD, MS. LAUD MISC. 385, f. 41v

❖ THE BUILDWAS BOOKS ❖

St Benedict decreed that there should be sufficient time in the monastic day for meditative or spiritual reading (*lectio divina*, as it was known). The importance of reading was further emphasised by the statutes of the Cistercian General Chapter, so it was essential for all abbeys to maintain a well-stocked library. The Bible, works of theology and spirituality, and writings of the monastic fathers were seen as especially appropriate. Also, many early Cistercians were prominent scholars, notably Bernard of Clairvaux (d. 1153), Ailred of Rievaulx (d. 1167) and John of Forde (d. 1214), with their writings distributed widely. As Abbot Richard (d. 1149) of Melrose was to put it: 'A cloister without literature is a tomb for living men.'

It is difficult to assess just how many books originally existed at Buildwas, though well over 100 works were recorded in the fourteenth century. What is so remarkable about the collection is the quantity of volumes that have survived. Around 50 have so far been identified, greater than any collection known from a British Cistercian abbey. Even more interesting is the fact that at least 15 of the books were made in the scriptorium at Buildwas itself.

It was Abbot Ranulf who began to assemble the collection in earnest. The earliest known work, St Augustine's *Sermons on St John's Gospel*, was copied at Buildwas in 1167. Augustine was among the best-represented early authors, along with St Cyprian, St Jerome and St Gregory the Great. Not surprisingly, the surviving books also include works by St Bernard (*Sermons*) and St Ailred (*The Mirror of Charity*), and there are a few texts devoted to the claustral life, such as Hugh of Fouilloy's *The Cloister* and Peter of Celle's *The Discipline of the Cloister*.

Even if book production at Buildwas declined in the late thirteenth century, scholarly reading certainly continued within the community. And, although some volumes were probably on the Oxford book market by the early fifteenth century, the bulk of the abbey's collection was doubtless maintained until the suppression.

CAMBRIDGE UNIVERSITY LIBRARY, MS. ADD. 4079, f. 28v

A folio from a fragmentary Cistercian Missal, almost certainly copied at Buildwas about 1170–80

Leave the sacristy and proceed to the next doorway, which leads into the chapter house.

Chapter House

The chapter house doorway is more imposing than the others in the east range, reflecting the importance of this chamber in the daily life of the community. Notice that the rounded head is arranged in stepped fashion, and that there were originally shafts in the outer jambs. The doorway is flanked by a window on either side.

Inside, the chamber is a work of singular architectural beauty [26]. The monks assembled here each morning, sitting on benches around the walls, whilst the abbot presided over the chapter meeting. This began with the reading of a lesson and a chapter from the *Rule of St Benedict*, after which saints and benefactors were commemorated and on certain feast days the abbot delivered a sermon. Matters of abbey business and estate administration might then be discussed by the community. The chapter meeting was also the occasion when faults were confessed, accusations made and penances assigned. Monks who had transgressed the *Rule* might be expected to fast on bread and water; flogging was reserved for more serious breaches of discipline.

The interior of the chapter house

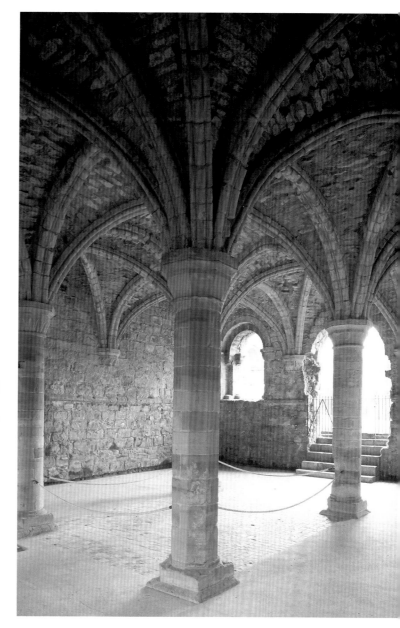

Right: Various tiles from the abbey have been placed in the floor of the chapter house

Above: A chapter house vault corbel, drawn by Joseph Potter (1847)

Below: St Bernard with his monks in the chapter house at Clairvaux

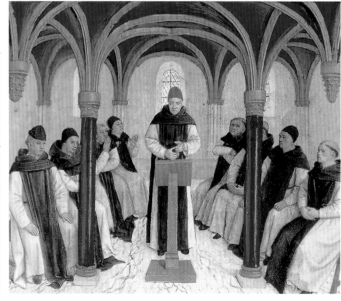

Arranged in nine bays or compartments, the Buildwas chapter house has a light, early Gothic character. In part, this was achieved by lowering the ground level during construction, so as to accommodate the fine rib-vaulted ceiling. The vault ribs spring from four slender central columns, alternately round and octagonal, all with octagonal capitals. At the walls, the ribs are supported on projecting corbels, featuring a variety of delicately carved scallop and foliage ornament.

As elsewhere in the abbey, the plaster-covered walls would have been limewashed, and marked with a lined pattern. In later centuries, the floor was doubtless covered with a

tile pavement. However, the chapter house was the customary burial place for former abbots, and there may well have been a need to accommodate their tomb slabs within any tile pattern. The existing tiles at the centre of the room are all Buildwas specimens, placed here in recent decades.

The last accessible doorway in the east range leads to the parlour [27].

Parlour

The parlour was the room where the monks were permitted to talk on matters of essential business without breaking the cloister rule of silence. The doorway from the cloister features a rounded outer head, and there was clearly a single shaft to each jamb. Within, there are two narrow rib-vaulted bays, with the ribs and wall corbels of a similar form to those seen in the chapter house.

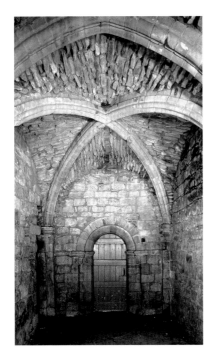

The *Rule of St Benedict* required that part of the monastic day should be spent at work, and for the Cistercian fathers this was to be taken literally. The early Buildwas monks therefore undertook a variety of appropriate tasks in the day room.

This was a substantial rectangular chamber, covered with a rib vault supported on two central columns. Most unusually, on the east side there was an open arcade, supported on columnar piers similar to those in the nave. The southern bay appears to have opened into a long room (or passage) running eastwards [29], possibly with a chapel at the far end. The two northern bays seem to have looked out to an open courtyard.

The Buildwas parlour seems to have doubled as a passage through the width of the range, accounting for the doorway in the end wall. Next to this, in the north wall, you will see another doorway (now blocked) which led through to the monks' day room.

Day Room

The monks' day room occupied the northern end of the east range. It lies outside the area currently managed by English Heritage, though it is shown in the bird's-eye view (inside front cover), and also appears on the ground plan at the end of the guide [28].

Left: The parlour was reserved as a room where the monks might discuss matters of essential business, without breaking the cloister rule of silence

The northern end of the east range would have served as the monks' day room. Unusually, its east wall (seen here from outside) was pierced by an open arcade. The wider southern arch (left) led into a narrow chamber

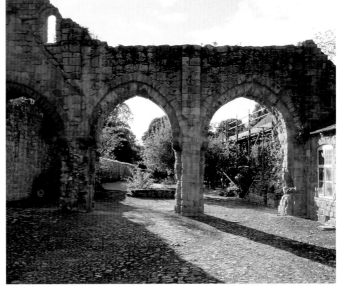

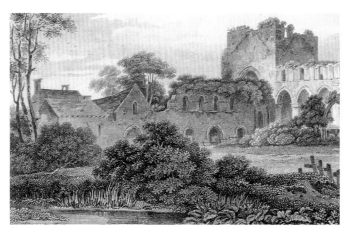

In this engraving of Buildwas (published in 1814), the east range appears more complete than it is today. Notice that four of the dormitory windows survive in the upper floor

Choir Monks' Dormitory

Now, walk into the centre of the cloister and look back towards the upper floor of the east range.

Although few of its features have survived, almost the entire upper floor of the east range would have served as the monks' dormitory. Looking up from the centre of the cloister, you will see traces of the small round-headed windows that lit the interior from this side. The bases of these windows sat over the line of the cloister roof, just above the horizontal string-course which runs along the face of the range.

Depending on the time of day, the monks would have gained access to and from their dormitory either by using the day stair, located in the angle between the east and north ranges, or by way of the night stair, observed in the north transept (p. 9).

If the internal arrangements followed early Cistercian custom, the monks' beds would have been set out along the side walls, with clothing chests filling the centre of the room. The simple wooden beds were probably covered with canvas mattresses. The monks were expected to sleep fully clothed in their habits. Given the size of the Buildwas dormitory, it might have accommodated anything between 30 and 50 monks.

The monks' latrine, or reredorter, was probably attached to the northern end of the dormitory.

Next, make your way to the north cloister alley to consider the details of the north range. The position of its cloister-facing wall lies just this side of the beech hedge.

THE NORTH RANGE

Sadly, very little survives of the north range as a whole, apart from a few sections of walling to be seen at the south-west corner. Originally, however, there was another impressive group of buildings along this side of the cloister, dominated by the monks' refectory or dining hall [**30**].

Before the 1160s, the English Cistercians invariably built their refectories parallel with the adjacent cloister alley. But in the later twelfth century new ideas on planning led

them to switch to a north–south alignment. Although we cannot be certain of the initial arrangements at Buildwas, on balance it seems likely that the community opted for the arrangement that had become almost universal by the first half of the thirteenth century.

Thus, we might expect the refectory to have run out from the centre of the range. Cistercian refectories were often rooms of grand proportion, flooded with natural light and open to the roof. For much of the year, the monks gathered here just once each day. Their communal meal was eaten in silence, broken only by one of the brothers reading from the Bible or another edifying text. In early centuries, the monks followed a strict vegetarian diet. Meals comprised little more than bread and two vegetable dishes, though a generous allowance of beer was also consumed. During the summer, a second meal was permitted later in the day.

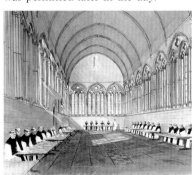

On the east (right) side of the refectory, there would have been a warming house [31]. Apart from the kitchen and infirmary, this was the only place in the abbey where a fire was allowed. It would burn between 1 November and Good Friday, offering the monks some respite from the cold of the cloister over the harsh winter months. In the angle between the warming house and the east range, there was a doorway leading to the day stair up to the monks' dormitory [32].

On the opposite (west) side of the range lay the kitchen [33], positioned where meals might be served directly to the refectories of both the choir monks and the lay brothers.

Turn around to look at the neat break in the wall which carried the cloister arcade near the north-west corner [34].

A small pillar divides the break into two sections, an arrangement almost certainly connected to the supply of piped water to a free-standing lavabo projecting into the corner of the cloister garth. The lavabo would have been used by the monks to wash their hands before going into the refectory for meals. At some point it must have been abandoned and was later replaced by a corner buttress supporting the arcades. A new lavabo was presumably built into the wall of the north range.

The break in the arcade wall in the north-west corner of the cloister probably marks the location of pipework, supplying and draining a free-standing lavabo in the garth

Cistercian refectories were very often grand rooms of noble proportion, flooded with natural light. There is a good example at Tintern, in south-east Wales, the details of which have been reconstructed in this drawing

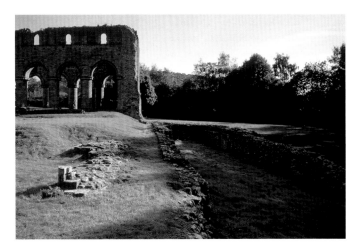

The west or lay brothers' range, seen from the northern end

A drawing of the late twelfth-century doorway from the lay brothers' lane into the west walk of the cloister, before its collapse in 1828

THE WEST RANGE

In the twelfth and thirteenth centuries, the west range of cloister buildings in Cistercian abbeys provided segregated accommodation for the lay brothers. At Buildwas, it sits on the lowest part of the site, its internal ground surface well below all other areas [35]. The west range also stood entirely clear of the cloister, separated from it by a distinct Cistercian feature known as a 'lane' [36].

The basement, with its massive buttresses on the south and west sides, may have provided cellarage. This was covered by a wooden floor, above which there were probably two more storeys. At cloister level, the northern end of the range presumably served as the lay brothers' refectory, conveniently located next to the

kitchen. There was probably more storage space to the south. Also at this level, a narrow passage ran between the outer and inner walls along the east side of the building. You will find a small doorway to this passage next to the west front of the church [37]. The upper floor of the range would have been occupied by the lay brothers' dormitory.

The lane was positioned immediately inside the range [36]. It was used by the lay brothers to enter the church to the south. Midway along the cloister side of this lane, there seems to have been an elaborate late twelfth-century doorway. The doorway survived until 1828, appearing in several early prints and drawings. Given the lack of a west door into the abbey church, it is tempting to see this cloister entrance as a fitting substitute, used for example during Sunday processions, when all parts of the monastery were visited by the community and blessed with holy water before High Mass.

THE INFIRMARY AND ABBOT'S LODGING

Having completed the tour of the buildings managed by English Heritage, it is worth considering the additional remains located on the north-east side of the site. Like the monks' day room (p. 19), they are in private ownership, but are depicted on the bird's-eye view, and on the ground plan at the end of the guide.

As completed over the course of the thirteenth century, the buildings here appear to have been grouped around a narrow open court [**38**], in an arrangement seen at other Cistercian abbeys throughout the country.

On the north side of the court was the monks' infirmary, reserved for the sick and aged members of the community. The principal building was a large aisled hall, now represented by an early thirteenth-century arcade of pointed arches running east to west [**40**]. Care of the sick was always regarded as important. Monks who were admitted to the infirmary, either because of chronic illness or perhaps to convalesce, could expect a somewhat more nourishing diet and greater comfort than in the communal life of the cloister.

The east side of the court was eventually closed off by a grand set of apartments for the private use of the abbot. The principal rooms were located on the upper floor, with perhaps a hall to the west [**40**], and a withdrawing chamber in the range looking south [**41**]. As built in the thirteenth century, the south-facing range featured a row of five decorative windows set in mini-gables projecting from the line of the main roof. In the late 1370s, the roof as a whole was rebuilt, probably in connection with an upgrading of the entire residence.

Following the suppression of the abbey in 1536, these buildings were remodelled to form part of the Tudor dwelling house built over this part of the site (p. 33).

The thirteenth-century arcade on the north-east side of the site represents an aisled infirmary hall

A panoramic view from the east side of the site, with the abbot's lodging to the right

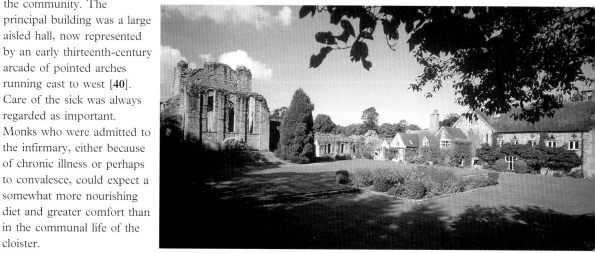

A HISTORY OF THE ABBEY

❖

SAVIGNIAC FOUNDATION

The Abbey of St Mary and St Chad at Buildwas in Shropshire was founded by Roger de Clinton, Bishop of Chester (1129–48), on 8 August 1135. Bishop Roger belonged to a new generation of Anglo-Norman monastic patrons, powerful men who were drawn to support the various reformed orders of monks and canons very much in vogue at this time. For Buildwas, Roger chose to turn to the highly fashionable Norman abbey of Savigny to provide the founding colony of monks.

Like all the reform communities of the late eleventh and early twelfth centuries, the Savigniacs were intent upon a return to the pure simplicity and primitive austerity of early monasticism (see box opposite). In north-west England they had already gained the support of several of the greatest magnates in the realm, and it was doubtless Roger's connections to this influential circle which led him to establish a further Savigniac colony within the bounds of his diocese.

Roger gave the Savigniac monks the site of the abbey itself, lands near Shrewsbury, and income from several other sources. In 1138, King Stephen (1135–54) issued Buildwas with a charter confirming these gifts and presenting the monks with important new privileges of his own. The brothers also attracted early grants from several local lords. Philip of Belmeis, for instance, gave them lands at Ruckley, and William fitz Alan donated the basis of the important estate across the river at Little Buildwas.

The fledgling community was initially headed by Abbot Ingenulf (1135–55), though it is difficult to say very much about the early internal life of the monastery. At best, we might suggest that the monks were likely to have been housed in temporary wooden buildings; their essential daily round of services to God perhaps carried out in a simple timber oratory.

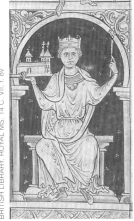

Count Stephen of Mortain, 'supermagnate' of the Anglo-Norman realm, was a major patron of the Savigniacs, and was responsible for introducing the order to England. He is depicted in this manuscript illumination as king (1135–54) and as a founder of abbeys

❖ THE SAVIGNIAC ORDER ❖

The Abbey of Savigny, mother house of the Savigniac congregation, owed its origins to St Vitalis of Mortain (d. 1122). Vitalis began his career as a secular clerk, but in the 1090s he chose to join other austere religious individuals and groups in the wild landscape of the Craon forest, pursing the life of a hermit and wandering preacher.

About 1105, Vitalis found his way to a secluded valley near the village of Savigny, on Normandy's borders with Brittany and Maine.

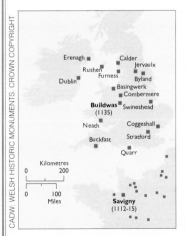

Map of Savigniac foundations by 1147

There he was joined by a group of like-minded disciples, and 'began to establish a monastery'. The pious community soon attracted the patronage of the rich and powerful, and between 1112 and 1115 the status of the house was formally elevated to that of an abbey.

Under Abbot Geoffrey (1122–39), these tentative beginnings were transformed into a flourishing monastic order. In less than two decades, the family comprised more than 30 abbeys, almost all of them staffed directly from Savigny itself.

The Savigniacs were introduced to Britain by the Anglo-Norman 'supermagnate', Count Stephen of Mortain, later king of England. In 1124, he settled a colony at Tulketh in Lancashire, though three years later the monks moved north to Furness. By 1147, there were 15 more houses of the order located across the British Isles, including Buildwas.

Despite this rapid growth, there were always signs of weakness in the Savigniac

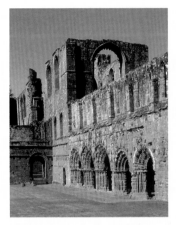

Furness Abbey, the first and most important Savigniac foundation in England

congregation, with a lack of effective control over the British daughter houses a particular difficulty. As pressure for change began to mount, Abbot Serlo (1140–53) could see that as a monastic experiment Savigny was on the verge of failure. Meanwhile, greatly impressed by St Bernard of Clairvaux, Serlo had petitioned for his entire order to be absorbed into the Cistercian community. The merger was approved at the General Chapter meeting of 1147.

This volume containing the Sermons of St Bernard was copied at Buildwas about 1200–30. The saint is probably depicted in the illumination

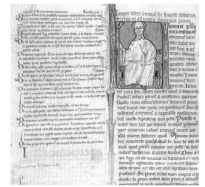

MERGER WITH THE CISTERCIANS

In 1147, just 12 years after its foundation, Buildwas (along with all the other houses of the Savigniac congregation) was absorbed into the rapidly expanding Cistercian monastic family (see box on p. 29). In common with the early ideals of this most successful of all the new religious orders, life and worship were to be characterised more than ever by a desire for solitude and simplicity. The abbey's economy became increasingly dependent upon the direct and intensive use of arable lands and pasture.

Under the remarkably gifted second abbot, Ranulf (1155–87), monastic life at Buildwas began to flourish. It was certainly during his

formative abbacy that Buildwas began to achieve significant progress with the construction of permanent stone buildings. From the 1150s onwards, masons were busy raising an abbey church typical of the form preferred by the Cistercians of the mid-twelfth century. Gradually, too, the main ranges of monastic buildings grouped around the cloister were taken forward towards completion. At much the same time, the Buildwas monks began to augment their basic collection of liturgical books. Works on theology and spirituality began to be copied and made into volumes to be read in the cloister.

As a distinct sign of the new status enjoyed by Buildwas, two other former Savigniac houses were soon submitted to its authority. St Mary's Abbey, Dublin, effectively became a daughter house in 1156, to be followed a year later by Basingwerk in north-east Wales.

In this thirteenth-century manuscript illustration St Stephen Harding (left) commissions monks to found new abbeys. To the right are the abbots of the four elder daughter houses of Cîteaux (p. 29). The group of working monks at the centre reminds us of the significance of manual labour to the early Cistercian way of life

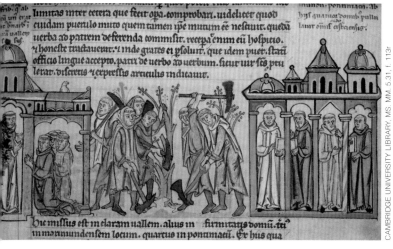

Then, in 1171–72, Buildwas was offered lands at Dunbrody in Ireland for the foundation of a brand new Cistercian abbey. In the end though, this was established as a colony of its better-placed daughter house at Dublin. In the meantime, throughout the 1170s and 1180s, Abbot Ranulf was a regular visitor to Ireland, and not merely to discharge his Cistercian duties. In 1172, for example, he was Henry II's chief representative at the Synod of Cashel, when the Irish bishops accepted the customs of the English Church.

On his death in 1187, Ranulf left his house spiritually refreshed and economically sound. Two years later, a general confirmation charter from King Richard I (1189–99) listed all the property then held by the abbey. Apart from the early grants, additional lands had been acquired in Shropshire, in neighbouring Staffordshire and further afield in Derbyshire. Another confirmation charter was granted by Bishop Hugh de Nonant (1185–98) in November 1192. Given that this charter was dated at Buildwas itself, and the fact that it was witnessed by a host of Shropshire abbots and other dignitaries, it is tempting to see it as marking a significant event in the life of the community, possibly the consecration of the completed abbey church.

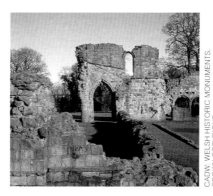

CADW: WELSH HISTORIC MONUMENTS. CROWN COPYRIGHT

As a sign of Buildwas Abbey's growing status, Basingwerk Abbey in north-east Wales was assigned to it as a daughter house in 1157

The Thirteenth Century

The good order and quiet prosperity which had come to characterise the earliest decades of monastic life at Buildwas seem to have been maintained throughout the thirteenth century. The abbots attended General Chapter meetings regularly, and were sometimes appointed to carry out duties on behalf of the order, such as acting as judges in disputes between other houses.

Building work continued, at least into the first half of the century. This was the period, for example, when the monks' infirmary hall was raised, and also when the abbot acquired his own separate lodgings. As it happens, about 1220, the community was granted the stone quarries at Broseley, possibly for building work already in hand. In 1232 the brothers were granted 30 oaks from the royal forest of Shirlett,

Patrons came to expect certain privileges from Cistercian abbeys, including burial within the church. This head of a knight effigy from Buildwas presumably represents one such early patron. It dates from about 1250-1300

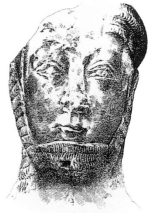

ENGLISH HERITAGE/SARA LUNT

As with all Cistercian abbeys, land was by far the most important economic resource during the early Middle Ages. Wherever possible, it was organised into distinctive farms, known as granges. This map shows the location of the principal Buildwas estates

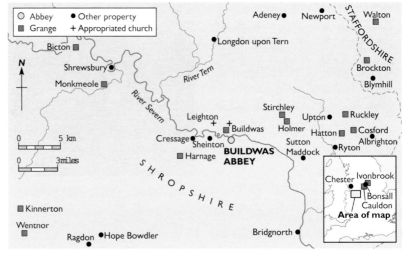

MAP BY RICHARD MORRIS

The Cistercians were great agricultural improvers, often cutting down and clearing, or 'assarting', large areas of woodland to create further arable acreage. In this manuscript illumination of 1111, two Cistercian monks are shown splitting a log

specifically for repairs to the abbey church, and they were given more timber for building in 1255.

All the while, the land-hungry monks were busy with the further expansion of their agricultural estate. In 1232, they acquired property at Harnage, possibly in a sale or mortgage transaction; and by the mid-thirteenth century the manor of Stirchley had been added to the abbey's holdings. Then again, as evidence of improvement, in 1277 the monks were given permission to 'assart', or clear, 60 acres (24ha) of their own land at Stirchley, and 10 years later – to rationalise several holdings – they parted with the outlying Staffordshire grange of Cauldon in return for lands at Adeney near Newport.

A picture of the abbey's economy at the end of the thirteenth century comes from a papal taxation document of 1291. The assessed income of the Shropshire and Staffordshire estates alone amounted to almost £114, with about 60 per cent of this coming from livestock and 20 per cent from arable farming. The importance of sheep farming, in particular, is further underlined by a surviving late thirteenth-century list of English monasteries supplying wool to Italian merchants. The annual Buildwas clip is given in the list as 20 sacks, representing anything up to 5,000 sheep. It is possible, however, that the abbey was acting as a 'middleman', supplementing the output of its own flocks with fleeces bought in from smaller producers.

❖ CISTERCIAN LIFE ❖

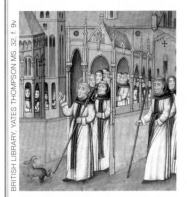

Cistercian monks arrive to colonise a new abbey: a fifteenth-century 'history picture'

The Cistercian adventure began at Cîteaux in Burgundy, in 1098. Here, in the midst of a particularly harsh landscape of marsh and forest, at a place described by later generations as one 'of horror and of vast solitude', a pioneering colony of monks settled to a new life of true austerity.

Teetering on the brink of extinction, the early community was desperately poor. At last, the tide began to turn during the abbacy of Stephen Harding (1109–33), the Englishman who drafted the sound constitution which ensured the future success of the enterprise. Growth and recruitment, meanwhile, had been transformed following the arrival of the charismatic Bernard 'of Clairvaux' (d. 1153) at the gates of Cîteaux in 1113. Within a few years, the emerging Cistercian order was enjoying massive popularity. By the mid-twelfth century, there were in excess of 330 monasteries scattered across the length and breadth of Europe.

The supreme guide for the Cistercian way of life was the *Rule of St Benedict*. As the chronicler William of Malmesbury wrote in the 1120s, they thought 'no jot nor tittle of it should be disregarded'. Alongside the *Rule*, instruction and governance were further provided by Stephen Harding's 'Charter of Charity', together with a series of statutes issued by the order's governing body, the General Chapter.

Fundamentally, the early Cistercians were committed to poverty, rejecting all sources of luxury and wealth. To ensure seclusion, their abbeys were to be sited away from towns and villages, 'far from the concourse of men'. They turned their backs on the refined black robes of the Benedictines, choosing to wear habits of coarse undyed wool, giving rise to their popular name, the 'white monks'. They wore no undershirts or breeches, followed a strict rule of silence and at first survived on a comparatively meagre vegetarian diet.

Supervision was maintained across the order through a mutual system of visitation among mother and daughter houses, even if in different countries. In addition, all abbots were required to attend the annual General Chapter meeting at Cîteaux.

St Benedict of Nursia, father of western monasticism, holding a copy of his Rule*: a thirteenth-century fresco at Subiaco, Italy*

THE LATER MIDDLE AGES

Buildwas Abbey continued to prosper over the early decades of the fourteenth century. As one indication of the community's overall standing, we might note that the abbot was summoned to attend more than a dozen parliaments between 1295 and 1324. Then, in the late 1320s, Edward III sought to persuade the Cistercian authorities to place the monks at Strata Marcella in Wales under the control of the Shropshire house, where it was said 'wholesome observance and regular institution flourishes'. Edward's motives were in part political; the Welsh abbey had certainly become a hotbed of conspiracy against English rule. But the General Chapter would go no further than to appoint the abbot of Buildwas a temporary visitor.

By the middle years of the fourteenth century, several episodes begin to hint at weaknesses in management and monastic discipline at Buildwas. Most notably, in April 1342, in circumstances shrouded in obscurity, an abbot whose name is lost to us was murdered. Thomas of Tong, one of his own monks, was placed under suspicion and imprisoned. Somehow he broke out, eluding all efforts to rearrest him.

The community, meanwhile, was left in total disarray, with two rival factions disputing the election of a new abbot. The goods of the house were squandered in the process, and by 1344 Buildwas was obliged to acknowledge a debt of £100.

Six years later, in 1350, simmering Welsh antipathy to Buildwas was shown when raiders from Powys, 'evildoers in no small number', broke into the monastery, pillaging its treasures, and taking the abbot and monks as prisoners. These border tensions were highlighted still further during the early fifteenth-century Welsh uprising led by Owain Glyn Dŵr, when the abbey's estates were said to have been ravaged by his followers.

The most lasting trend in the abbey's affairs over the fourteenth century was the steady change in its economic basis. Buildwas was not exceptional; Cistercian houses everywhere were being forced to abandon the ideals of direct exploitation, leasing out more and more land in return for fixed rents. A fall in the number of lay brothers, coupled with rises in wages for hired labourers, accelerated the process. And then, in the spring of 1349, the Black Death arrived in Shropshire, surely compounding the difficulties Buildwas must have been experiencing with labour shortages.

The abbey's estates were said to have been ravaged during the Owain Glyn Dŵr uprising. This is an impression of the Welsh leader's seal

In the early 1340s, Brother Thomas of Tong was accused of murdering his own abbot. In this fourteenth-century manuscript illustration, a monk is depicted suffering for his misdemeanours

BRITISH LIBRARY, ROYAL MS. 10E. IV .f 187

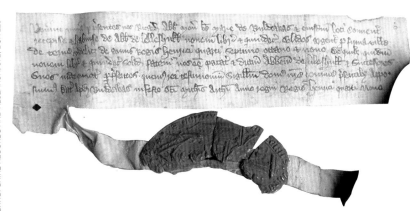

One of a series of receipts (1397–1421) of the abbey's land transactions, bearing the seal of the abbot and convent

Whether the pestilence had any direct impact on the community is not recorded, nor is it clear if the Welsh raid of 1350 had any long-term effect. Nevertheless, by 1377 there were no more than six monks at the house, and by 1381 the number had fallen still further, to just four.

Few events of particular note are recorded for Buildwas through the fifteenth century. In the Wars of the Roses (1455–87), however, the monks suffered somewhat at the hands of the Leightons, who tried to make them repurchase lands which had been granted by earlier generations of their family. By this time, only the home grange at Little Buildwas was worked directly by the abbey. Elsewhere, leases on property were being extended in a bid to raise hard cash. About 1494, for example, Abbot Richard leased the estate at Harnage to his brother for a period

of 51 years. Again, in 1534, now with the signs of impending disaster close at hand, the abbey sold a 95-year lease on its Stirchley property for £20, even before the previous lease had expired.

Sadly, too, it seems the community had fallen from those standards of monastic discipline which had so characterised the early life of the house. A visitor appointed by the General Chapter in 1521 reported that the abbey was 'very far from virtue in every way'.

A nineteenth-century drawing of a knight effigy in Leighton parish church. The effigy, dating from about 1320–40, is thought to have been brought here following the suppression of Buildwas Abbey. It may represent Sir Richard Leighton V, whose family members were certainly important patrons of the house

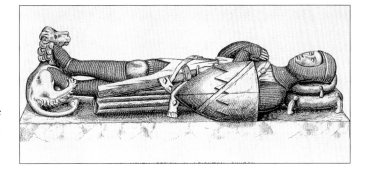

King Henry VIII, seen here in an illuminated initial at the opening of the Valor Ecclesiasticus, *the great survey of monastic property, 1535*

In 1537, the site of the abbey, together with virtually all of its former holdings, was granted to Sir Edward Grey, Lord Powis (d. 1551). This is the opening corner of the grant document

SUPPRESSION AND CONVERSION

In the first decades of the sixteenth century, the religious orders in England were coming under increasing attack. Some people were harshly critical of their spiritual and moral standards, others resented their stranglehold on the land and property markets. An almost inevitable process of change was hastened by the actions of King Henry VIII (1509–47): on the one hand the king was determined to break from papal authority, on the other he was in need of money.

In 1534, the Act of Supremacy established Henry as the supreme head of the church throughout his realm. The monasteries soon came under increasing scrutiny, partly from a genuine desire to bring about the long overdue process of reform.

But in an exercise masterminded by the King's Vicar-General, Thomas Cromwell (d. 1540), the financial benefits of even a partial closure of the 800 or so religious houses located across England and Wales became readily apparent.

As a preliminary to the process of suppression, a comprehensive report and valuation of monastic property was essential. In the results of the great survey, known as the *Valor Ecclesiasticus* (1535), the net annual income of Buildwas Abbey was given as nearly £111. In the meantime, Cromwell had appointed further commissioners to look into the spiritual affairs of the monasteries. The Shropshire visitors were at Buildwas in the late summer of 1535. They reported finding 12 monks, of whom four were accused of grave moral faults.

In March 1536, an act was

passed ordering the suppression of those monasteries whose income fell below a benchmark figure of £200 per year. Approximately 200 houses disappeared in 1536–37, representing the first stage in the total suppression of the monasteries, a long-drawn-out process which was to continue through to 1540.

As for Buildwas, it had been visited by yet another set of commissioners in April 1536. They had found eight monks in residence, under the last abbot, Stephen Green. There was also a body of servants, together with a number of dependents living in the abbey complex, including a priest, several people living on alms and three corrodians or pensioners. The house was said to be 'in convenient repair', with the lead on its roofs and the bells valued at over £94.

The abbey was finally surrendered late in 1536. Anything of value would have been catalogued, weighed and reserved for the king. Other disposables such as glass and timber were often auctioned on the spot. The monks themselves were dispersed, some to monasteries that were to survive for several more years.

In July 1537, the site of the abbey, along with virtually all of its former holdings in Shropshire, Staffordshire and Derbyshire, was granted to Sir Edward Grey, Lord

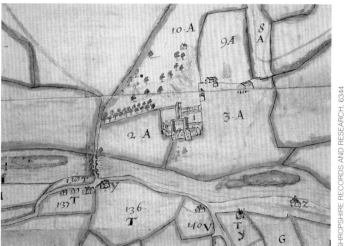

SHROPSHIRE RECORDS AND RESEARCH, 6344

Powis (d. 1551). At first, he took the properties on payment of an annual rent of just over £55, but in due course he acquired them outright. Sir Edward appears to have settled the entire estate on his illegitimate son, also named Edward.

It was the younger Edward Grey who converted the buildings on the north-eastern side of the complex, including the abbot's lodging and the infirmary, for use as a grand country house. Depicted on a map of 1650, the house was apparently of substantial courtyard form, and would almost certainly have been accompanied by ornate gardens. The earthworks representing these gardens, probably with elaborate water features, have recently been identified in the area to the west and north-west of the abbey church and cloister.

In the second half of the sixteenth century, parts of the monastic buildings at Buildwas were extended for use as a grand Tudor dwelling house by Edward Grey the younger. The house, and its surrounding landscape, are depicted on this map of 1650

LATER HISTORY

This superb watercolour of the church at Buildwas (1772) was painted by Michael 'Angelo' Rooker (1743–1801). He was one of many artists who came to the site in search of the picturesque

In 1648, Buildwas was sold to Sir William Acton, and in the later seventeenth century it became the property of Walter Moseley (d. 1712). Thereafter, the Moseleys held the estate through into the twentieth century. Sadly, though, the fortunes of the Elizabethan dwelling and its gardens began to decline. The house, at some point reduced in size, was occupied for a time as a tenanted farmstead, with the abbey church and the now ruinous cloister the subject for artists in search of the

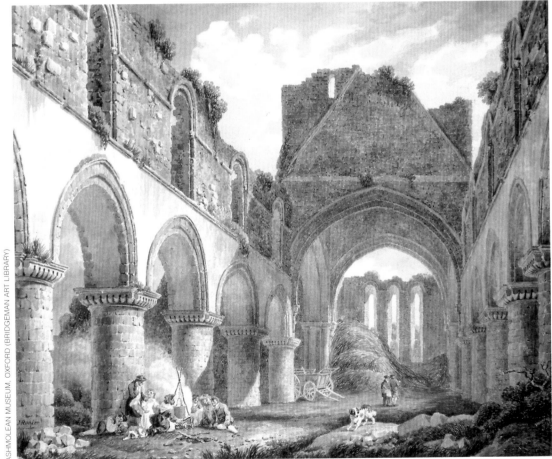

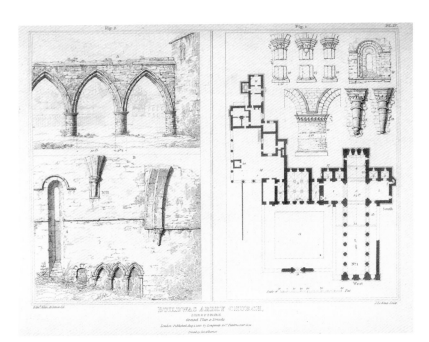

BUILDWAS ABBEY CHURCH.
Shropshire

In the early nineteenth century, Walter Michael Moseley (d. 1827), produced a history of the abbey. His account was accompanied by a number of engraved plates, including this example showing a plan and various architectural details

picturesque. Among those who came to draw and to paint at Buildwas in the late eighteenth century were Paul Sandby, Michael 'Angelo' Rooker and J. M. W. Turner.

In the early nineteenth century the site was owned by Walter Michael Moseley (d. 1827). He was one of the first gentlemen to look into the antiquarian interest of the buildings, publishing an account of the remains in 1814. The architecture was studied in far greater detail by John Chessell Buckler (d. 1894), whose fascinating survey survives in manuscript at the British Library in London. Buildwas also attracted the attention of the Lichfield architect and antiquary,

Joseph Potter, who in 1847 produced a remarkable portfolio of drawings of the buildings.

A watercolour of the abbey, seen from the south-west, by John Sell Cotman (1782–1842)

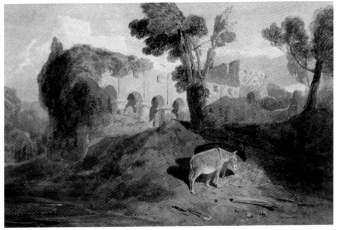

An early twentieth-century photograph of the abbey, seen across the tracks of the Great Western Railway's Severn valley line

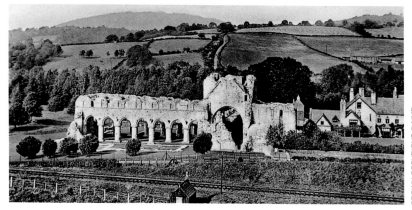

It was the perilous condition of the ivy-clad ruins in the 1920s which led to the site being taken into the care of the state

CROWN COPYRIGHT © NMR

CROWN COPYRIGHT © NMR

The surviving fragments of the post-monastic house were renovated and extended by the Moseley family in the later nineteenth century. By the early 1920s, however, there were mounting concerns about the perilous state of the fabric of the adjacent ruins. Fortunately, in 1925, they were placed in the guardianship of HM Office of Works by the then owner, Major H. R. Moseley. The house remained in private ownership, and was finally sold in the early 1960s. Today this part of the site belongs to Ironbridge Power Station. Since 1984, the consolidated and conserved areas of the church and cloister ranges have been in the care of English Heritage.

Acknowledgements

The author would like to thank Richard Bond, Graham Brown, Glyn Coppack, Paul Everson, Peter Fergusson, Stuart Harrison, Richard Lea, Paul Stamper and Malcolm Thurlby for their kind assistance in the compilation of this guidebook.

Further Reading

◆ Janet Burton, *Monastic and Religious Orders in Britain 1000–1300* (Cambridge 1994).

◆ Glyn Coppack, *The White Monks: The Cistercians in Britain 1128–1540* (Stroud 1998).

◆ Peter Fergusson, *The Architecture of Solitude: Cistercian Abbeys in Twelfth-Century England* (Princeton 1984).

◆ Bennett D. Hill, *English Cistercian Monasteries and their Patrons in the Twelfth Century* (Urbana 1968).

◆ Christopher Norton and David Park (editors), *Cistercian Art and Architecture in the British Isles* (Cambridge 1986).

◆ David M. Robinson (editor), *The Cistercian Abbeys of Britain: Far from the Concourse of Men* (London 1998); reprinted in paperback (London 2002).

◆ Jennifer M. Sheppard, *The Buildwas Books: Book Production, Acquisition and Use at an English Cistercian Monastery, 1165–c. 1400* (Oxford Bibliographical Society, series 3, 2, Oxford 1997).

◆ Mary Suydam, 'Origins of the Savignac Order: Savigny's Role within Twelfth-Century Monastic Reform', *Revue Bénédictine*, 86 (1976), 94–108.

◆ The Victoria History of the Counties of England, *Shropshire*, 2 (Oxford 1973), 50–59.

◆ David H. Williams, *The Cistercians in the Early Middle Ages* (Leominster 1998).